HOW TO BE DRAWN

ALSO BY TERRANCE HAYES

Lighthead

Wind in a Box

Hip Logic

Muscular Music

HOW TO BE DRAWN

TERRANCE HAYES

PENGUIN POETS

PENGUIN BOOKS

Published by the Penguin Group
Penguin Group (USA) LLC
375 Hudson Street
New York, New York 10014

USA | Canada | UK | Ireland | Australia | New Zealand | India | South Africa | China
penguin.com
A Penguin Random House Company

First published in Penguin Books 2015

LIBRARY OF CONGRESS CATALOGING-IN-PUBLICATION DATA

Hayes, Terrance.
[Poems. Selections]
How to be drawn / Terrance Hayes.
pages ; cm.—(Penguin poets)
ISBN 978-0-14-312688-1
I. Title.
PS3558.A8378A6 2015
811'.54—dc23
2014045785

Printed in the United States of America

7 9 10 8

Set in Frutiger Light • Designed by Ginger Legato

for the ones like us

CONTENTS

Acknowledgments ix

I. TROUBLED BODIES

What It Look Like 3

The Deer 5

How to Be Drawn to Trouble 7

New York Poem 10

As Traffic 12

Wigphrastic 14

My Life as a Hummer 17

Gentle Measures 19

A Concept of Survival 24

Who Are the Tribes 26

II. INVISIBLE SOULS

Black Confederate Ghost Story 35

How to Draw an Invisible Man 38

Barberism 40

The Carpenter Ant 42

American Sonnet for Wanda C. 44

Like Mercy 45

A. Machine 47

Portrait of Etheridge Knight in the Style of a Crime Report 48

Elegy with Zombies for Life 51

Instructions for a Séance with Vladimirs 54

III. A CIRCLING MIND

The Rose Has Teeth 65

Antebellum House Party 67

Reconstructed Reconstruction 69

We Should Make a Documentary About Spades 72

For Crying Out Loud 75

Model Prison Model 77

Some Maps to Indicate Pittsburgh 80

New Jersey Poem 82

Self-Portrait as the Mind of a Camera 84

How to Draw a Perfect Circle 90

*

Ars Poetica for the Ones Like Us 95

Notes 97

My sincere thanks to the editors and staff of the following publications for first acknowledging the poems (and previous versions of the poems) in this manuscript.

The American Reader, American Studies, The Baffler, CHORUS—A Literary Mixtape, Conduit, Crazyhorse, Guernica, Gwarlingo.com, heartjournal online.com, huffingtonpost.org, *Huizache, jubilat, Los Angeles Review, Manor House Quarterly, The New Yorker, New York Times T Magazine, The Normal School, Poet Lore, Poetry Magazine,* poets.org Poem-A-Day, *A Public Space, Rattle, The Hampden-Sydney Poetry Review,* storyscapejournal. com, tate.org.uk: *Tate Etc. Magazine, The Times Literary Supplement, Tin House, Terminus,* and *Vinyl.*

"New Jersey Poem" also appeared in *The Best American Poetry 2013,* edited by Denise Duhamel and David Lehman. "The Rose Has Teeth" also appeared in *The Best American Poetry 2012,* edited by Mark Doty and David Lehman. "Model Prison Model" also appeared in *2011 Pushcart Prize XXXV: Best of the Small Presses.*

The poem "Who Are the Tribes" first appeared as a chapbook published by Pilot Books in 2011, with thanks to Betsy Wheeler. "Like Mercy" also appeared in the chapbook *Between Ghosts* (Center for Book Arts, 2010), with thanks to Sharon Dolin.

"Gentle Measures" was written for the "Gods and Monsters" theme in the Hugo House literary series. "How to Draw an Invisible Man" also was published online by the United States Postal Service for the centennial

Ralph Ellison stamp. "Instructions for a Séance with Vladimirs" was first commissioned as part of the *Book Wings* project, a collaboration between the University of Iowa's International Writing Program and the Moscow Art Theatre, with thanks to Nate Brown and Christopher Merrill. "Antebellum House Party" was first written for *Found Anew: New Writing Inspired by the South Caroliniana Library Digital Collections*, with thanks to Ray McManus.

Deepest gratitude to Yona Harvey and Paul Slovak for their help with this collection, and to the United States Artists Zell Fellowship for its generous support. Thanks as well to friends who influenced this manuscript through encouragement and conversation: Elizabeth Alexander, Rob Casper, Radiclani Clytus, Toi Derricotte, and Shara McCallum.

A letter moves backwards with its own wings . . .

—Rammellzee

I.

TROUBLED BODIES

Dear Ol' Dirty Bastard: I too like it raw,
I don't especially care for Duke Ellington
at a birthday party. I care less and less
about the shapes of shapes because forms
change and nothing is more durable than feeling.
My uncle used the money I gave him
to buy a few vials of what looked like candy
after the party where my grandma sang
in an outfit that was obviously made
for a West African king. My motto is
Never mistake what it is for what it looks like.
My generosity, for example, is mostly a form
of vanity. A bandanna is a useful handkerchief,
but a handkerchief is a useless-ass bandanna.
This only looks like a footnote in my report
concerning the party. *Trill* stands for what is
truly real though it may be hidden by the houses
just over the hills between us, by the hands
on the bars between us. That picture
of my grandmother with my uncle
when he was a baby is not trill. What it is
is the feeling felt seeing garbagemen drift
along the predawn avenues, a sloppy slow rain
taking its time to the coast. Milquetoast
is not trill, nor is bouillabaisse. *Bakku-shan*
is Japanese for a woman who is beautiful
only when viewed from behind. Like I was saying,
my motto is *Never mistake what it looks like*
for what it is else you end up like that Negro

Othello. (Was Othello a Negro?) Don't you lie
about who you are sometimes and then realize
the lie is true? You are blind to your power, Brother
Bastard, like the king who wanders his kingdom
searching for the king. And that's okay.
No one will tell you you are the king.
No one really wants a king anyway.

Outside Pataskala I saw the deer with a soft white belly,
the deer with two eyes as blind as holes, I saw it leap
from a bush beside the highway as if a moment before
it leapt it had been a bush beside the highway, and saw
how if I wished it, I could be the deer, a creature bony
as a branch in spring, and when I closed my eyes, I found
the scent of muscadine, the berry my mother plucked
Sundays from the roadside where fumes toughened
its speckled skin and seeds slept suspended in a mucus
thick as the sleep of an embryo. It is the ugliest berry
along the road, but chewed it reminded me of speed,
and I saw when I was the deer that I didn't have to be a deer,
I could become a machine with a woman inside it
moving at a speed that leaves a stain on the breeze
and on the muscadine's flesh, which is almost meat,
the sweet pulp a muscadine leaves when it's crushed
in the teeth of a deer, or a mother for that matter
or her child waiting with something like shame to be fed
a berry uglier than shame, though it is not like this
for the deer, it is not shame because the deer is not human,
it is only almost human when it looks on the road
and leaps covering at least thirty feet in a blink, the deer
I cannot be, the dumb deer, dumb and foolish enough
to ignore anything that runs but is not alive, a trafficking
machine filled with a distracted mind and body deadly
and durable enough to deconstruct a deer when it leaps,
I'm telling you, like someone being chased. I remember
a friend told me how, when he was eight or nine,
a half-naked woman ran to the car window crying her man

was after her with a knife, but his mother locked the doors
and sped away. Someone tell him his mother was not
a coward. That's what he thinks. Tell him it was because
he and his little brother were in the car, she would not
let the troubled world inside. It was no one's fault.
The mind separated from the body. I could almost see
the holes of her eyes, the white fuzz on her tongue,
the raised buds soft as a bed of pink seeds,
the hole of a mouth stretched wide enough to hold
a whole baby inside, I could almost see its eyes
at the back of her throat, I could definitely hear its cries.

The people I live with are troubled by the way I have been playing
"Please, Please, Please" by James Brown and the Famous Flames
All evening, but they won't say. I've got a lot of my mother's music
In me. James Brown is no longer a headwind of hot grease

And squealing for ladies with leopard-skinned intentions,
Stoned on horns and money. Once I only knew his feel-good music.

While my mother watched convicts dream, I was in my bedroom
Pretending to be his echo. I still love the way he says *Please*
Ten times straight, bending the one syllable until it sounds
Like three. Trouble is one of the ways we discover the complexities

Of the soul. Once, my mother bit the wrist of a traffic cop
But was not locked away because like him, she was an officer

Of the state. She was a guard at the prison in which James Brown
Was briefly imprisoned. There had been broken man-made laws,
A car chase melee, a roadblock of troopers in sunblock.
I, for one, don't trust the police because they go around looking

To eradicate trouble. *T-R-oh-you-better-believe*
In trouble. Trouble is how we learn what the soul is.

James Brown, that brother could spice up any sentence he uttered
Or was given. His accent made it sound like he was pleading
Whether he was speaking or singing. A woman can make a man
Sing. After another of my mother's disappearances, my father left her

Bags on the porch. My father believes a man should never dance
In public. Under no circumstances should a grown man have hair

Long enough to braid. If I was a black girl, I'd always be mad.
I might weep too and break. But think about the good things.
My mother and I love James Brown in a cape and sweat
Like glitter that glows like little bits of gold. In the photo she took

With him, he holds her wrist oddly, probably unintentionally
Covering her scar. There's the trouble of being misunderstood

And the trouble of being soul brother number one sold brother
Godfather dynamite. Add to that the trouble of shouting
"I got to get out!" "I got to get down!" "I got to get on up the road!"
For many years there was a dancing competition between

My mother and father though rarely did they actually dance.
They did not scuffle like drums or cymbals, but like something

Sluggish and close to earth. You know how things work
When they don't work? I want to think about the good things.
The day after the Godfather of Soul finished signing just that
All over everything in the prison, all my mother wanted to talk

About were his shoes. For some reason, he had six or seven pairs
Of Italian leather beneath his bunk suggesting where he'd been,

Even if for the moment, he wasn't going anywhere.
Think about how little your feet would touch the ground
If you were on your knees pleading two or three times a day.
There are theories about freedom, and there is a song that says

None of us are free. My mother had gone out Saturday night,
And came home Sunday an hour or so before church.

She punched clean through the porch window
When we wouldn't let her in. I can still hear all the love buried
Under all the noise she made. But sometimes I hear it wrong.
It's not James Brown making trouble, it's trouble he's drawn to:

Baby, you done me wrong. Took my love, and now you're gone.
It's trouble he's asking to stay. My father might have said *Please*

When my mother was beating the door and then calling to me
From the window. I might have heard her say *Please* just before
Or just after the glass and then the skin along her wrist broke.
Pleasepleasepleasepleaseplease, that's how James Brown says it.

Please, please, please, please, please, Honey, please don't go.

In New York from a rooftop in Chinatown
one can see the sci-fi bridges and aisles
of buildings where there are more miles
of shortcuts and alternative takes than
there are Miles Davis alternative takes.
There is a white girl who looks hijacked
with feeling in her glittering jacket
and her boots that look made of dinosaur
skin and R is saying to her *I love you*
again and again. On a Chinatown rooftop
in New York anything can happen.
Someone says "abattoir" is such a pretty word
for slaughterhouse. Someone says
mermaids are just fish ladies. I am so
fucking vain I cannot believe anyone
is threatened by me. In New York
not everyone is forgiven. Dear New York,
dear girl with a bar code tattooed
on the side of your face, and everyone
writing poems about and inside and outside
the subways, dear people underground
in New York, on the sci-fi bridges and aisles
of New York, on the rooftops of Chinatown
where Miles Davis is pumping in,
and someone is telling me about contranyms,
how "cleave" and "cleave" are the same word
looking in opposite directions, I now know
"bolt" is to lock and "bolt" is to run away.

That's how I think of New York. Someone
jonesing for Grace Jones at the party,
and someone jonesing for grace.

Sounds like the hook in a chart topper
A rapper mouths squatting like a gilded animal
In the middle of a bustling boulevard
Of bumpers and bumping bikini rumps,
Chains, chains, chains, but it is meant to conjure
My half brother, and the girls the news says
He'd kidnapped or persuaded with knuckles
Before the police rushed in knocking him
Like a lover no longer loved to the motel floor
His long arm was chained to a cell phone
The one time I met him he called me brother
And said our father had more children like us
All over town while UGK's "Int'l Players Anthem"
("My bitch a choosy lover, never fuck
Without a rubber") bumped in the background
Foolishly, I did not think the worst of the music
I adore had anything to do with having power
Over anyone else, the naked women as bountiful
As traffic, the half-naked men who cannot grow
Stiff without looking at reflections of themselves
While the camera glares an inch from their genitals
Might have wanted before porn simply to play
Hardcore like the hardcore rappers paid to be
Wrapped in chains of rhyme and the arms of women
Working for men who want to fill the soft pockets
Of everything with something of themselves
A camera swelled the locks on my brother's body
In the courtroom the way police lights swelled
Over the girls he trafficked miles for money

And taxed for gas back home and the protection
He offered them from the belligerent johns
And, when called for, protection from himself
Before the judge denied bail, the ruling
Was on the news: "Columbia man charged
With human sex trafficking," he will live in a cell
With the beautiful solitude chained about his throat
Growing over time as permanent and illegible
As what has been scratched tooth and nail
Into the cells—the music I have been playing
All my life is about pimps and who will be pimped,
But when my daughter is listening, I play something else

WIGPHRASTIC

after Ellen Gallagher

Sometimes I want a built-in scalp
that looks and feels like skin. A form of camouflage,
protection against sunburn and frostbite,
horsehair that covers the nightmares and makes me civilized.

Somebody slap a powdered wig on me so I can hammer
a couple sentences like Louis XIV small and bald
as a boiled egg making himself taller by means
of a towering hairpiece resembling a Corinthian column

or maybe a skyscraping Kid with no Play wig
worn by someone playing *N.W.A*
at a penthouse party with no black people.

We up in the club humming *Hmm-mmm, hey Mamma*
while our numbskull caps underscore the brain's captivity.

Somebody slap me. Norman Mailer's essay
"The White Negro: Superficial Reflections on the Hipster"
never actually uses the word *wigger*. I'd rather say *whack*.
It may be fruitful to consider me a philosophical psychopath.

We clubbing in our wigs of pleas and longing.
The ladies wear wigs of nots,
knots of nots: would nots, do nots, cannots,

wigs dipped in dye swirl on their scalps, off their scalps,
sides of scalps, their center parts, and irrigated plaits.

Flirty bangs dangle below a bow clip of sparkle.
A lady places her bow about-face to place her face in place.
Which is a placebo of place, her face is a placebo!

Let's wear ready-made wigs, custom-made wigs,
hand-tied wigs and machine-made wigs.

"No Negro can saunter down a street with any real certainty
that violence will not visit him," wrote Mailer.
Bullets shout through the darkness. Dumb people are dangerous.

"Calamity pimps come out of the woodwork
and start to paddle their own canoes."
This was a white dude's response to the death of Martin.
Let's beat that apathy wig off him.

Let's get higher than God tonight like the military wives
of Imperial Rome smiling in the blond and red-haired wigs
cut from the scalps of enemy captives. Somebody slap me.

We awash in liquor watching the coils curl,
curls coil, coils coil, curls curl on the girls.

Nonslip polyurethane patches, superfine lace,
Isis wigs, Cleopatra wigs, Big Booty Judy wigs
under the soft radar-streaked music of Klymaxx
singing, "The men all pause when I walked into the room."

The men all paws. Animals. The men all fangles,
the men all wolf-woofs and a little bit lost, lust,
lustrous, trustless, restless as the rest of us.

In my life the wigs eat me. The wish to live awhile on the mind
of another human is not inhuman. The wish to slide
for a while inside another human, it is not inhuman.

If you like "like" like I like "like," you should wear a hairpiece.
It is peace of mind. It is artistic. It is a lightweight likeness,
comfortable, wash and wear, virtually looking and feeling
with virtually no side effects. Let me hear you say,

"This wig is terrific!" A colored despair wig
for your colored despair, an economic despair wig,
a sexual despair wig, a wig for expressive despair,
political despair, a movable halo. New and improved,

your wig can be set upon the older wig
just as the older wig was set,
when it was newer, upon the wig beneath it.
Where's your wig? Wear your wig. Your wig is terrific.

My life as a hummer followed my life
as a gas of complex and commonplace
observances concerning, for example,
pathos, martyrs, enemies, and ruin.
I had not visited Detroit, but I knew
the road there touched eccentrics
differently. I became a maker of sounds
as abstract as kittens in a box taped shut.
The hum had always been in me.
Where once any tune was a tongue-slapped
syllable, any tune came to be an insatiable
yuck. Whatever cannot be said
when being suffocated, can be hummed
fairly easily. I devoted myself to sumptuous
moos and hallelujahs. Look around you:
only the absence of certain people suggests
you did not sleep the whole journey.
All else is machinery that seems to be saying
"Destroy." It makes me remember the last time
I was in Detroit I thought of jumping
through a window on a hotel's thirteenth floor.
I felt I had fallen like a ladder into a plot
of saggy flowers. I felt like the crestfallen
letters of the Motown marquee half-spelling
the name of David Ruffin, a man born
but not buried in Whynot, Mississippi.
I fell like a letter from a sack of fan mail
declaring, "Dear David, come back to Detroit
before it is destroyed by the sound of guzzling!"

I am like anyone: truck and whatever
is run over by the truck. Ask me about hunger,
and I will hum something very unlikely.

GENTLE MEASURES[1]

CHAPTER I. THREE MODES OF MANAGEMENT
> First, I would like to have with 196 women from the world's
> 196 nations 196 children, then I would like to abandon them.
> I know it's not that easy. But when I am home, I can't wait
> to get moving, when I am moving I can't wait to get home
> again. Part of me loves when I've got no place to be.

CHAPTER II. WHAT ARE GENTLE MEASURES?
> For the occasion she learns she will have no father
> my Sri Lankan child will have to imagine, difficult as it is,
> the depth of history, how humanity endures because it is,
> at most, an idea. This scenario is also for my mother flirting
> with a man twice her age and for the lonely child in me.

CHAPTER III. THERE MUST BE AUTHORITY
> I will have a son named High Jinx, and a son named 44,
> and a son named Mary. Some of my sons will wear bags
> on their heads. Some of my sons will wait their whole lives
> to board an ark called *American Beauty.*

CHAPTER IV. GENTLE PUNISHMENT OF DISOBEDIENCE
> Mothers, various retributions should be divvied in the light
> of each child's sins. My children will not always be godly.
> You have my permission to punish them as you would like
> to punish me. (Your hands and knees must be bloodied.)

[1] The poem's title and section titles are taken from Jacob Abbott's 1871 book *Gentle Measures in the Management and Training of the Young; or, The Principles on Which a Firm Parental Authority May Be Established and Maintained, Without Violence or Anger, and the Right Development of the Moral and Mental Capacities Be Promoted by Methods in Harmony with the Structure and the Characteristics of the Juvenile Mind.*

CHAPTER V. THE PHILOSOPHY OF PUNISHMENT
I would like to abandon the child of a mother who dies
in a Luxembourg train wreck, and a mother kidnapped
by banana farmers in Belize; a mother taking refuge
alone in a mountain cave during a Peruvian flood.
Goddamn, I want to be as hardcore as my daddy.

CHAPTER VI. REWARDING OBEDIENCE
Thinking of me, two or three myths their brains devise
will begin to divide in them, the tangible cells untangling
themselves until my absence seems to recede. My children
will find grease on their fingers after touching pictures of me.

CHAPTER VII. THE ART OF TRAINING
Sometimes I want to catch the hand of a child and go
"Life! Life! Life!" Sometimes I imagine an old naked woman waiting
as her tub fills with water. Or a knock-kneed girl using her face
as a shield. But I will not claim to know other people's loneliness.

CHAPTER VIII. DELLA AND THE DOLLS
When my Korean daughter falls for the man who dresses
his lovers like dolls, I will not be there to say, "Being a doll
is as close as a toy can come to slavery," I will not say, "Isn't it
exciting: the noon teas, the personalized songs and cradling?"

CHAPTER IX. METHODS EXEMPLIFIED
Children, here are some of my favorite things: the tiny tongue
painted inside a doll's tiny mouth, a phonograph record
spinning like a girl in a black skirt. Also the family drawing
one of you made, though the father in it looks nothing like me.

CHAPTER X. SYMPATHY:—I. THE CHILD WITH THE PARENT
My little Belgian boy in a hat decorated with buttons
pulled from the shirt I left behind, my little Syrian girl
with a shoe box waiting for birthday cards she will not receive,
my farm boy with the tomatoes he tried selling to neighbors
who wanted pears. I plan to never keep photographs of them.

CHAPTER XI. SYMPATHY:—II. THE PARENT WITH THE CHILD
My mother had me when she was sixteen. The angle of her teeth,
she can barely shut her mouth, may have been inherited
from her father before he ran away. She told me, "If a strange man
ever appears at your door, kick him in his grin, Baby.
Kick him even if he begins to sing to you about me."

CHAPTER XII. COMMENDATION AND ENCOURAGEMENT
Let's praise everything that spurs the spirit to creativity.
The tin cup my father rattles until its poison spills,
how easily a mouth erupts with belief. Let's praise
how much we love without loving, how little we sing while singing.

CHAPTER XIII. FAULTS OF IMMATURITY
We can try to praise the light-blue powder of family
because it is not made of stone, it is not mist. You can't hold it
long, but this is true of many things. Somewhere
in this brain is also my father's misery. And whether it is better
to forgive or let yourself be forgiven eventually.

CHAPTER XIV. THE ACTIVITY OF CHILDREN
My child with no one to teach her how to skin a Bolivian goat
or make a necklace of Tanzanian wolf teeth, my kindergartners
in Madagascar and Cuba, my daughter whose stepfather
will die in a Kenyan coal mine, my daughter whose boots will fail
to warm her in the Ukrainian snow: their lives will be better without me.

CHAPTER XV. THE IMAGINATION IN CHILDREN

This is a wish for the child sleeping in grass that has wilted
a little, for the child lazing in the pool of a beachside hotel.
This is for the child who overhears his mother cry
into the phone: "Don't you put the bad mouth on me!"

CHAPTER XVI. TRUTH AND FALSEHOOD

Sometimes my prayers begin, "Darkness, is that you
at my skull?" Because that's one version of pain,
I'm always like "Angel, leave me the fuck alone." I'm like
"Blame the devil of longing." I have said I am in love with beauty,
but my heart is so mangled, it spills blood on everything.

CHAPTER XVII. JUDGMENT AND REASONING

In the high schools where the janitors speak French,
in Swaziland and Switzerland, on the small islands
where nuns show their knees, in places the word for "Father"
means nothing to me: their lives will be better without me.

CHAPTER XVIII. WISHES AND REQUESTS

I would like to leave you to the moody cruelty and nurture
of your mothers, Children, to the complex rites and rituals
of your countries, to God gazing like a cop on a bike, to cocoa
and buzzards and crap inventions and the gospel of possibility.

CHAPTER XIX. CORPORAL PUNISHMENT

The bald-headed mother dreaming through cancer of the sprawl
of highways and the wide-open wilder Wilderness, the fluid
holy light she can put her hand through, the rain beating
"I am" "I am" all over her body: it's got nothing to do with me.

CHAPTER XX. CHILDREN'S QUESTIONS

At each door I want to slip on my shoes and say to each woman, "Do what you do, Mother Goose." And should one of you find me, Children, I'll downright lie and snap, "Shadow, why do you follow me so? Ain't you a long way from home too?" You don't need me to know what it means to be lonely. I won't look back. I won't look back at you.

A CONCEPT OF SURVIVAL

after Jenny Holzer

It was a good enough request at first
written on prophylactic packages PROTECT ME
FROM WHAT I WANT the shy genes exploding
just outside the late streetlights and later
in other quarters it was found stamped
inside all the Midwestern Bibles PROTECT ME
FROM WHAT I WANT not just in hotels where
sometimes the condoms were sheathed
and unsheathed but in the pews and desks
of churches and churchgoers in nursing homes
where the aged lived long enough to find pain
shameless my grandmother's uncle jumped
naked on his bed the last time we visited him
our mood was baffled and ugly PROTECT ME
FROM WHAT I WANT appeared on neon signs
and banners it was typed on the ticker tape strips
buried in fortune cookies so that opening one
after my meal I looked over my shoulder
to a vanishing waitress I was told her shift
was done I'd fallen in love with her as I always fall
for anyone taking my order sometimes fortune
explodes quietly PROTECT ME FROM WHAT I WANT
to be thoroughly drunk and immune to hunger
to dream a means of survival a bubble of luck
milk pours from the pastoral holes in the body
or blood when you are beaten tender in the woods
I want to feel the trees around me I want you
to smell the leaves on my breath PROTECT ME
FROM WHAT I WANT paranoia is a form of intuition

it carries a flashlight and never sits with its back
to an exit the water always threatens to come indoors
I want to enter someone else's hide and hide
I want to sleep enough to never need sleep again
too many years have passed since I went dancing
since I cried publicly or was so small my mother
could lift me with her one free arm from the floor

WHO ARE THE TRIBES

	1st	2nd	3rd	4th	5th
Tribe	**Antler**	**Spike**	**Quixote**	**Bill**	**SixFour**
Color			Ink		Mirror
Poison	Beauty	Sunrise		$$$$	
Smoke	Fools		Oxygen		
Loves		Jive		$$$$	Ghosts

1. BEEFS

The tribe who loves burial vs The tribe who loves being alive vs

The tribe whose color is pennied vs The tribe whose color is sunset vs

The tribe whose poison is touch vs The tribe whose poison is hunger vs

The tribe who lives before the past vs The tribe who lives behind the mirror vs

The tribe who smokes fire vs The tribe who keeps the gun as a pet

2. HOW TO FORGET

in a city that was a village that was a tribe and is a tribe again
we named ourselves the disciples of the darkness
because we looked at so little of ourselves from day to day
a birthmark could be mistaken for a strange new rash

we named ourselves the disciples of spit because our lives were
infested with chatter the vacuous transmissions floating
at the eye of our entourage because love was a hive
of cut-downs and chains laced the exits we made our music

stand on the skull like horns the bad lyrics of roosters clucking
their place in the world because how terrible it must have been
to live every day in any year before this one divided into junctions
of vermin wounded and winded and unwinding homespun bargains

prayers and complaints the magic of whiskey the magic of money
a black country with black woods around tribes talking about fucking
other tribes up because if it is true the points of a star represent the fingers
of a hand it is also true what we cannot touch does not exist

3. PLAUSIBLE MOTTOS

Someone in the first tribe says:
"Why didn't God save Aretha Franklin from herself? Tell me that."

Someone in the fifth tribe says:
"Humming instead of speaking does mysterious things to you."

Someone in the third tribe says:
"The day I got burned *I wanted to be burned.*"

Someone in the second tribe says:
"The good thing about evil is it gets old too."

Someone in the fourth tribe says:
"Seems there's a lot of money in just being black these days."

4. WHATSHISNAME

On the tip of my tongue is the name
of that _____ Mr. – – – – – –
who knew so little of himself
he signed his name with a dash
and left his mark on all of us.
Among the many reasons to distrust – – – – – – were:

(1) his theatrical grin, (2) his chitchat was a simulacrum of syntax, a meticulous mishmash of "Fuck thisness" and "Fuck thatness," (3) that jacket he claimed he got in vintage New York I know his momma found in a thrift store, (4) his overwrought S-curled Afro!

His cackles often emerged
blackly enough to suggest
he'd swallowed something
that should have been too big
and rambunctious to fit down his throat.

5. THE ANTIDOTE FOR INVISIBILITY

~~We did not want to be the bullshit quietude, or the errant sparkle of hairs damp as cursive on the neck and forearms of someone tethered to labor, we did not want any man or woman's skin-pocked funk and amnesiac chatter, we did not want the sunstroked dirt to cover our kicks or footsteps, the fields of it holding the cities we did not call home, the dead we did not call kin, the humble punk plant life and signage and fence posts, we did want to be nailed to anything rooted to earth.~~

6. TRIBE SENTENCE COMPLETION

"When I have nothing to think about I like to think about BL_____SS, which, as you probably know, is like thinking of nothing because it was thought of as nothing for many years."

Answer key:

 If you are a **Bill** it's BLANKNESS.

 If you are a **Spike** it's BLANDNESS.

 If you are a **Quixote** it's BLACKNESS.

 If you are a **SixFour** it's BLEAKNESS.

 If you are an **Antler** it's BLACK ASS.

7. BILL REPARATION

Here's me willing to spend no $$ It amounted to a whole lot of $$
and at the very ♥ was a wish to be all ♥
It's not that I wished to be so slow-legged I could die of hunger
Inside me was the echo of rap stars caterwauling "how about me"
Inside me was a trunk of house speakers that made my block (((vibrate)))
My "how did I get so fucked up" always ended with "so what"
That's me reciting the lines I was dealt and swallowing
I didn't love Americans but I loved America when she sobbed
touching my cheek in the darkness to see if I was crying too
(A culture of what she wanted me to think she was
versus a culture of what she wanted me to be)

8. BEEFS WITHIN A TRIBE

the sight of wood burning vs
footsteps through snowfall vs
meditation as medication vs
city lights vs
feeling the intangible vs

someone else's cigarette smoke vs
sludge on your coat vs
self-absorption vs
country air vs
thinking the intangible

9. TRIBE HUNT

We called some time or another every soul's mother
a fool and that was a reason to scrap. A six- or eight-legged
skirmish in a back lot, a whole lot of blacks. Someone
who could not hold his Bull cried, "Courage
is what cowards call cockiness!" At least I think that's what the fool said
after I called him a fool. I can't say for sure, I was running
with my ears turned down when he shot that little pistol overhead.

The Antlers: "cut and run"
The SixFours: "eat and run"
The Quixotes: "run down"
The Billies: "run dry"
The Spikes: "run cold"

What can you run from
that does not inevitably find you,
that you do not inevitably return to,
that does not inevitably run
from you? "Still waters run deep,"
someone said that too. Before
the creation of the word *run*
some people were prone to say
"I want to do what water do"
or "what rabbit do," "what harvest do."
The bloodhound's paws, they fall
in the rhythm of paws. My black ear to
the ground. Boys born with the animal
gene, the night's long legs running
behind them, and the river
draped in a movement like running too.

10. ANTLER

All of us have seen beauty pass into something else,
have seen it waiting beneath a tree until the shade breaks free
and covers it, some of us have even been covered by it,
gripped it like a lover or a machine swerving from the road
where the pines are like people buried headfirst off the shoulder,
graveyard or gridlock, the sound of a horn entering the mind,
the deer corpse crushed against a guardrail, its eyes wide
open as an officer of the state scraped the body free.

11. SPIKE PREMONITION

I don't want to go on no more adventures with Spike, the leader of the Spikes, because my good sense tells me he is someone Death wants to educate. Cool as marbles of sweat and covered in "wows" when he walks pretty much anywhere in town. The song he sings he says is a tribute to women. Its translation is "Baby Got Back." *Sike* ain't one of his words but *shut-up* is. He says shut up when somebody sneeze and everybody obey. The windows shutter, the widows shutter, the winos hallucinate. He appears sometime at my door like a mythical creature with surprise sprouting from his face.

12. IDEOGRAMS AND/OR IDIOMS

The Spikes \Incisor/
Of twanging that talk that sounds like money, that ricochet encasement that's twelve degrees wide. Oooed & Eeeeked with possibility. & that able-joyed.

The SixFours))Helix((
Lil Elf. Cornucopian. Damn near ascetic dust net. Pliant curl-a-plenty. Boomerung & Blung. The rustle in the sprawling that is noise listened to carefully, but the kind of noise that is nothing.

The Billies <Apex>
Nicknamed because of them staunched cellar doors. A flared signage. A walk-in exhibit of the cavernous. An accoutrement of cartilage & every empty vial worth scenting.

The Quixotes >Orbitals<
Eye candor but without weeping & weeing, I. Looking like weaponry, I. Looking on a body who fine it seem infinitely, I. So impossibly engorgeous she seem to be a glittering, I.

The Antlers =Fontanel=
On all the Falstaff boys. Implicit pullover. Of a shine. A lucid basket case.
Of brushable or blasted follicles. Or a nude wood & knowledge no one on
the other side of the hill will possess.

13. TRIBE PARTY

A school of boys around a girl, for example.
They make verbs of *bauble*, whatever that means.
Bubbles of oohs ooze and the mouths
of each second do their guppy tick, that gulping shit
to live. "I want to go down in history,"
I've heard ordinary people say that. I've heard names
become catchphrases, I've seen names needled deep
into the skin, an ink pumping like oil leagues
beneath the surface of day. Could be we'll say "our"
with our last breaths: the girls who become unfortunate;
the boys with their tongues hard on the air, starving to dance
with no idea what happened or why it happened to them.

II.

INVISIBLE SOULS

Attention, African-American apparitions hung,
burned, or drowned before anyone alive was born:

please make a mortifying midnight appearance
before the handyman standing on my porch
this morning with a beard as wild as Walt Whitman's.

Except he is the anti-Whitman, this white man
with Confederate pins littering his denim cap and jacket.
(And by *mortify*, dear ghosts, I mean scare the snot out of him.)

I wish I were as tolerant as Walt Whitman
waltzing across the battlefield like a song
covering a cry of distress, but I want to be a storm

covering a Confederate parade. The handyman's
insistence that there were brigades of black
Confederates is as oxymoronic as terms like
"civil war," "free slave." It is the opposite of history.

Good-bye, plantations doused in Sherman's fire
and homely lonesome women weeping
over blue and gray bodies. Good-bye, colored ghosts.

You could have headed north if there was a south
to flee. In Louisiana north still begins with Mississippi,
as far as I know. East is Alabama, west is Texas,

and here is this fool telling me there were blacks
who fought to preserve slavery. Good-bye, slavery.
Hello, black accomplices and accomplished blacks.

Hello, Robert E. Lee bobblehead doll
on the handyman's dashboard whistling Dixie

across our postracial country. Last night
I watched several hours of television and saw
no blacks. NASDAQ. NASCAR. Nadda black.

I wish there were more ghost stories
about lynched Negroes haunting the mobs
that lynched them. Do I believe no one among us
was alive between 1861 and 1865?

I do and I don't. We all have to go somewhere
and we are probably already there.

I know only one ghost story featuring a brother
in Carrollton, Alabama, dragged to the center of town
in a storm for some crime he didn't commit.

As he was hung lightning struck a window
on the courthouse he's been haunting ever since.

Attention, apparitions: this is a solicitation
very much like a prayer. Your presence is requested
tonight when this man is polishing his civil war relics
and singing "Good Ol' Rebel Soldier"[1] to himself.

[1] Oh, I'm a good old Rebel soldier, now that's just what I am;
For this "Fair Land of Freedom" I do not give a damn!
I'm glad I fought against it, I only wish we'd won,
And I don't want no pardon for anything I done.

Hello, sliding chairs. Hello, vicious whispering shadows.
I'm a reasonable man, but I want to be as inexplicable
as something hanging a dozen feet in the air.

And then when Ralph Ellison's corpse burst
open, I discovered his body had been hoarding
all these years a luscious slush, a sludge
of arterial words, the raw and unsaid pages
with their plots and propositions, with their arcs
of intention and babbling, with their mumbling
streams and false starts and their love
and misanthropic thrusts, tendons of syntax
unraveled from his bones and intestinal cavities,
the froth of singing, stinging, stinking ink,
reams of script fraught with the demons,
demagogues, and demigods of democracy,
demographies of vague landscapes,
passages describing muddy river bottoms
and elaborate protagonists crawling
through a foliage greener than money in America
before America thought to release anyone
from its dream, the waterlogged monologues
one who is unseen speaks burst suddenly
from Ralph Ellison's body and because I mean to live
transparently, I am here, bear with me,
describing the contents: the fictions envisioned
by Emerson and immigrants, the dogmas,
aboriginal progeny, scholastic recriminations,
dementia, jubilee, hubris in Ralph Ellison,
Duke Ellington's shadow, a paragraph
on the feathered headdress of Marcus Garvey,
some of it was pornography, some of it alluded
to Negroes who believe educating black kids

means teaching them to help white people feel
comfortable, some of it outlined the perks
of invisibility, how we are obliged to eschew
the zoo, the farm animals, it had something
to do with captivity, flayed in the clinical light
the notes printed on the underside of his flesh
were reversed but readable mirrored in the metal
of the medical table and I wanted to print it all
properly in a posthumous book in the name
of prosperity and proof the genius we believed
he'd wasted had been waiting all these years
for a simple death sentence to break free.

It was light and lusterless and somehow luckless,
The hair I cut from the head of my father-in-law,

It was pepper-blanched and wind-scuffed, thin
As a blown bulb's filament, it stuck to the teeth

Of my clippers like a dark language, the static
Covering his mind stuck to my fingers, it mingled

In halfhearted tufts with the dust. Because
Every barber's got a gift for mind reading in his touch,

I could hear what he would not say. He'd sworn
To never let his hair be cut again after his daughter

Passed away. I told him how my own boy,
His grandchild, weeps when my clippers bite

Behind his ear, but I could not say how
The blood there tastes. I almost showed him

How I bow my own head to the razor in my hands,
How a mirror is used to taper the nape.

Science and religion come to the same conclusion:
Someday all the hair on the body will fall away.

I'm certain he will only call on me for a few more years,
The crown of his head is already smoother

Than any part of his face. It shines like the light
In tiny bulbs of sweat before the sweat evaporates.

It was when or because she became two kinds
of mad, both a feral nail biting into a plank
and a deranged screw cranking into a wood beam,
the aunt—I shouldn't say her name—

went at the fullest hour of the night,
the moon there like an unflowered bulb
in a darkness like mud, or covered in darkness
as a bulb or skull is covered in mud,

the small brown aunt who, before she went mad,
taught herself to carpenter and unhinged,
in her madness, the walls she claimed
were bugged with tiny red-eyed devices

planted by the State or Satan's agents, ghosts
of atheists, her foes, or worse, the walls
were full of the bugs she believed crawled
from her former son-in-law's crooked mouth,

the aunt, who knows, as all creatures know,
you have to be rooted in something tangible
as wood if you wish to dream in peace,
took her hammer with its claw like a mandible

to her own handmade housing humming,
"I don't know why God keeps blessing me,"
softly, madly, and I understood, I was with her
when the pallbearers carried a box

made of mahogany from her church to a hearse
to a hole in the earth, it made me think
of the carpenter ant who carries within its blood
an evolved self-destructive property, and on its face

mandibles twice the size of its body,
and can carry on its back, as I have seen on TV,
a rotted bird or branch great distances
to wherever the queen is buried—kingdom:

Animalia, phylum: Arthropoda, tribe: Camponotini,
the species that lives on wood is, like mud, rain,
and time, the carpenter's enemy, yes,
but I would love to devour the house I live in

until it is a permanent part of me,
I would love to shape, as Perumthachan,
the master sculptor, carpenter, and architect
of India, is said to have shaped, a beautiful tree

into the coffin in which I am to be buried,
I know whatever we place in a coffin, the coffin
remains empty, I know nothing buried is buried,
I don't know why God keeps blessing me,

I don't know why God keeps blessing me.

Who I know knows why all those lush-boned worn-out girls are
Whooping at where the moon should be, an eyelid clamped
On its lightness. Nobody sees her without the hoops firing in her
Ears because nobody sees. Tattooed across her chest she claims
Is BRING ME TO WHERE MY BLOOD RUNS and I want that to be here
Where I am her son, pent in blackness and turning the night's calm
Loose and letting the same blood fire through me. In her bomb hair:
Shells full of thunder; in her mouth: the fingers of some calamity,
Somebody foolish enough to love her foolishly. Those who could hear
No music weren't listening—and when I say it, it's like claiming
She's an elegy. It rhymes, because of her, with effigy. Because of her,
If there is no smoke, there is no party. I think of you, Miss Calamity,
Every Sunday. I think of you on Monday. I think of you hurling hurt
Where the moon should be and stomping into our darkness calmly.

I swear a dim yellow light settled around the head
Of the little choirgirl who'd stepped forward to sing
"More Like Jesus" and almost everyone was moved.

Much later, I watched a boy slap the sin out of a man
Old enough to be his grandfather on the street outside

My window and I was happy, for a moment,
That two people could display such shamelessness,
Such a form of love. I would have said something

But my window was shut, the street almost empty
When I stepped out like a man of God.

Who can live like that? We should not have been
Expected to lift the holy choirgirl into our arms,
Though we could have, skinny as she was, light

As the branch of a tree reflected in a river.
I was not one of the women thrashing in the aisle

Like somebody drowning. *Work me till I drop,
Sweet Jesus, my Rock,* I never said that.
But I know if I was a singer, I'd be more godly.

I'd know how to exit a room flooded with grief.
When I called out to the old man as he walked away,

I swear he was singing *Whatever, whatever* to himself.
God hardly listens when we talk anyway. After spells
Of nothing sometimes I go *Shedeadshedeadshedead*

To myself because that's how I pray. If you're a church,
Dear Lord, you're less than stained glass to me.

I want to take a hammer, I want to hammer, I want
To take a hammer to the mirror on your smallest toe.
Because, eureka, a little prayer don't doctor shit.

I can almost imagine the look of your scars,
Dear Lord, when I find you.

Hey, I am learning what it means to ride condemned.
I may be breaking up. I am doing 85 outside the kingdom

Of heaven, under the overpass and passed over,
The past is over and I'm over the past. My odometer

Is broken, can you help me? When you get this mess-
Age, I may be a half-ton crush, a half tone of mist

And mystery, may be trooper bait with the ambulance
Ambling somewhere, or a dial of holy stations, a band-

Age of clamor and spooling, a dash and semaphore,
A pupil of motion on my way to be buried or planted or

Crammed or creamed, treading light and water or tread
And trepidation, maybe. Hey, I am backfiring along a road

Through the future with "I am alive" skidding across my tongue.
When you get this message, will you sigh, *My lover is gone*?

PORTRAIT OF ETHERIDGE KNIGHT IN THE STYLE OF A CRIME REPORT: PART I

<table>
<tr>
<td rowspan="3">C R I M E</td>
<td>Related Reports
Yes, you should run down Knight's criminal records. Readers will be especially interested in the circumstances under which he first was imprisoned.</td>
<td colspan="3">Additional Offenses Listed in Narrative
During a visit home to Mississippi Knight claims to have broken into the office of a doctor, possibly a dentist, to acquire drugs. It is unclear what drugs Knight obtained. The following is a reconfigured dramatization of events.</td>
<td>Case Number
There is a number between every number.</td>
</tr>
<tr>
<td>Code Section and Description (one incident only)
When the store clerk wasn't looking, Knight pulled cash from the register. The judge gave him eight years upstate.</td>
<td>Month
Therefore we can assume this happens between months of summer.</td>
<td>Day of the Week
On the previous day the clan gathers for a picnic.</td>
<td>Year
They wear denim and cotton in the style of rural black people in the 1950s.</td>
<td>Time
Their laughter, chatter, multi-scented smoke, and funk burns through the edges of the day.</td>
</tr>
<tr>
<td colspan="5">Location of Incident (or address) City
The sun sets late in Memphis. You can get there from Corinth, Mississippi, as late as ten o'clock and still have to wait for the darkness.</td>
</tr>
</table>

PORTRAIT OF ETHERIDGE KNIGHT IN THE STYLE OF A CRIME REPORT: PART II

V	**Victim's Name** We are not sure whether Knight knew the doctor's name. He was called Doctor, whether he was a physician or a dentist.				**Residence Address** City State Zip In the cell's darkness, the code of ancestry breaks.
I **C** **T** **I** **M**	**SEE RACE CODE LEGEND ON TOP OF BACK PAGE** In the darkness the cells break.	**RACE** He was called Doctor whether he was black or white.	**SEX** He had a homely wife and a shy nurse. His wife may have also been his nurse.	**DATE OF BIRTH** There are root doctors in foreign countries who believe a man's whole life can be mapped according to his birthday.	**Relation to victim/suspect** Etheridge had come across a witch doctor in a bar in LA. A guy with a pink scar running like a seam, a dividing line, down the middle of his face. When he asked Etheridge where he was from, Etheridge took it to mean if he could find his way to Mississippi, he'd find his way.

PORTRAIT OF ETHERIDGE KNIGHT IN THE STYLE OF A CRIME REPORT: PART III

	Article Name	STOLEN / RETRIEVED	Identification Numbers	Brand/Make or Manufacturer	Miscellaneous Description	Value
P						
R	Diacetyel-morphine	is stolen.	Because pleasure is a form of metamorphosis, a man doses off dreaming of Mississippi and wakes as a horse at a barbed fence.			
O						
P	Points aiming to puncture skin	are retrieved.	Insulin and tuberculin syringes, subcutaneous injectors, hypodermic needles ranging from ½ an inch to 3 inches.			
E						
R	Cures for depression	are stolen.	I am embarrassed by how bad I am with money. I don't know what to do with it or what to do without it. I believe the high is not symbolic, it is not dialectic. It is a form of metamorphosis.			
T						
Y	Cures for joy	are stolen and retrieved.	The only thing stronger than joy is my hunger for joy. It's a fact, the bones of a horse last longer than the horse.			

HAIR LENGTH/TYPE	HAIR STYLE	FACIAL HAIR	COMPLEXION	GENERAL APPEARANCE	DEMEANOR	SPEECH	VOICE

Bald Afro Braided Collar Shoulder Processed Thinning Ponytail Coarse Wavy Greasy Thick Short Neck Wig Clean-shaven with acne. Sideburned and dark. Disguised, disgusting, good-looking, unkempt. Sometimes the suspect is angry and then inhumanly calm. The suspect may be disorganized. His lisp may be muffled or raspy. He may speak with a Negro accent. He may be lost in thought.

No one was arrested that day. A boy questioned just outside Memphis claimed he saw a dark gray horse trotting across his front yard that night.

The trouble with living like thinking is feeling is it's not
Really living. I think, for example, these are good times
Save the mornings I want to say "Shame on you mother-

Fuckers" to the motherfuckers trafficking homemade posters
Of death on the corner between my home and the cemetery
That holds among its dead the bones of the great pianist

Mary Lou Williams, the mother of jazz. Music was her child
Because she had no child. For Mother's Day my children
And I took my wife to visit Mary Lou's headstone (May 8, 1910–

May 28, 1981). We found it unmoored and untended,
Unattended on a hillside. People who say *don't live in the past*
Don't have a real sense of the past, would you agree with that?

Life is not about what you learn, really, but what you remember.
I was in a diner once when I saw a young mother passed out
With her face in her plate. I have been thinking about the horrified

Expression of her little boy as a waiter approached the booth.
Near me a lady in a business suit sighed, "For that kind
Of woman, abortion should be free." Think about the theory

That crime rates have declined since Roe versus Wade versus
The theory that sexually transmitted diseases have increased.
Think about identity versus ideology versus idiocy, the Center

For Bio-Ethical Reform versus the sinners of the bio-unethically
Formed. The Center for Life and Hope versus the Center for Death
And Despair. Because thinking is feeling, I think about death

All the time: the food under my nails, the nails underfoot,
The skullish sockets packed with dirt. Maybe the soul is tethered
To the body like an embryo even when the body is no longer alive.

Maybe zombies have taken over. Are you for the Humans for Life,
The Families for Life, the Armed Forces for Life, or are you for
Something else? Because thinking is feeling, there are thousands

Of compartments and pigeonholes in my brain, there are polemics
And porn flicks and utopian blueprints, court briefs, sketches,
Graphs, philosophical theories like "Cruelty is a form of laziness,"

But there is only one version of death. It takes work to imagine
The ineffable, which I think is the word for something that can't be
Effed up. I think the sanctimonious are worse than people who hate

Music, would you agree with that? At this very moment, they are fighting
about the order of things we should value: God, Family, Country—
No: Love, Justice, Money. I can no longer grasp the logic

Of conflicts. In the pro-life versus pro-choice debate, for instance,
It's the *versus* that's of interest to me. Remember Fred Williamson
Saying to the friend who became his enemy at the end of *Bucktown*,

"I don't want to kill you, I just want to beat the hell out of you"?
I love the lovely restraint in that. Cruelty *is* pretty damn lazy, actually.
It takes more effort to earn someone's love than it does to punch

Someone in the face. May you be punched in the face, may you weep
Until your nose is fat and crumpled as the hood of a child's raincoat,
That's my curse for the self-righteous. That's the "Thug Life for Life"

In me, a former self versus a self who wants to change, Cassius Clay
Versus Muhammad Ali, who said, "A man who views the world
The same at fifty as he did at twenty has wasted thirty years of his life."

The trouble with thinking thinking is feeling is sometimes
There is no feeling. Twenty years ago I would not have believed
My unborn child would still be here pushing a cry out of me.

INSTRUCTIONS FOR A SÉANCE WITH VLADIMIRS

after Vladimir Mayakovsky

Feeble Heart, Beware: do not contact the spirits ill prepared.

TWO REASONS SÉANCES WORK

1. The dead are lonely. Symptoms include a faint witchcraft, a boom-bap, some claptrap played in a parallel room. I'm thinking of "Self Destruction" performed by the Stop the Violence Movement all-stars. "I am too tough to die." This is the motto of the dead when they are alive.

2. We are lonely. Our symptoms include talking alone, dancing alone, and making love alone at least once a day. The symptoms of loneliness, it is possible, evidence a metaphysical hunger. The mouth on your navel is your own. You sprawl on a two-dimensional floor weeping. Your life is a series of unacknowledged sacrifices. (Only ghosts understand this.)

CREATE AN EXCLUSIVE BELIEVERS-ONLY INVITATION LIST

Invite as many open-minded Vladimirs as possible, for they are like magnets attracting the Vladimirs who are dead. Vladimirs with eighties-style haircuts will attract top-hat Vladimirs. Vladimir the plumber will attract Vladimir the swimmer. Change your name to Vladimir.

What you want is a Vladimir brigade. A mirror of the living reflecting the dead and vice versa. In the towering dusk, groaning and brushing Vladimirs. To overcome the cold one must conjure the supernatural world.

NEVER CONDUCT A SÉANCE BY YOURSELF UNLESS YOU WANT TO GO INSANE

I changed my name to Vladimir and we talked. I got the feeling of water underfoot. A version of vertigo. To overcome hunger you must swallow

without biting. I wanted to drink, yes. So I changed my name to Vladimir. I like most people named Vladimir.

SET UP A SPIRIT-FRIENDLY ENVIRONMENT

The action should take place in a provincial room. The action should take place in a winter barn. The action should take place in an elevator. Do not put nails on the roads or stairs. Do not put dirt in the gasoline tanks or punch.

Let's say you've gone back in time. The action should take place among the unwieldy entourages of the Grand Prince Vladimir in a time of plague, pneumonia, paranoia, intellectual starvation, spiritual exhaustion, pratfalls, missteps. It should be twelve o'clock noon; five soldiers should pass the house rapidly. The exact speed of light in a vacuum is roughly 300,000,000 meters per second.

FIVE THINGS YOU WILL NEED TO HOLD A PROPER SÉANCE

1. A CIRCULAR TABLE

Around which the skulls shall faint and float backward with the skeleton of momentum and the gaping jaws and the clinging teeth, the little red heart beating center stage. A circular route of negative and positive transgressions. A means of disappearance and peace.

2. CANDLES

Let your tar-shaped shadow stretch over the stack of Vladimir's books. Never read by candlelight, by the way. I didn't say sunlight. Moonlight. Fire. Your tar-shaped shadow, that double exposure. Burn red candles if you desire Vladimir in a halo of warplanes. Burn borrowed candles if you desire a Vladimir with a beautiful gangrene gaze. Break a single candlestick and burn each half if you desire the presence of a bald old mug-shot Vladimir.

3. INCENSE

Cinnamon provides energy and lures cats to the window; frankincense expands consciousness and aids in meditation; sandalwood grounds the participants and helps them to stay focused. Beware: there is such a thing as too much symbolism.

4. MUSIC

"Self-obstruction, you headed for self-abstraction." I'm sick of that song. Play some Vladimir Padwa, it will impress your guests. Maybe his *Tom Sawyer* ballet or his Concerto for Two Pianos. Or maybe play a DJ Vlad (Vladimir Lyubovny) mash-up mixtape remix.

5. TAPE/VIDEO RECORDER

A man in one of the windows outside your house will be watching you.

SELECT A MEDIUM

If you can find your way to Russia's red-light districts of distraction tall with vodka and smitten, look for the women cooing "ooooh" in dark paneled rooms, safe-housed and exhausted enough to channel Death. Look for the woman lifting an uncoupled breast to the camera in a room without windows. If you can hear the mechanical hum of the soul seeping out of her body, she's the medium you should use.

SUMMON THE SPIRIT

Begin by joining hands with the people on either side of you and closing your eyes. (A certain nobility is implicit in saying what I don't believe and hoping you believe it.) No door will open without creaking. Drugs help and are easy to use but hard to acquire. I have two hands and they are not as similar as they seem.

POSSIBLE PASTIMES OF VLADIMIR IN THE AFTERLIFE
VLADIMIR COUNTING PAPER CLIPS
VLADIMIR DRIVING A NIGHT ROAD IN A WINDSTORM
VLADIMIR DREAMING OF ARROWS
VLADIMIR READING A BOOK ABOUT FLYING
VLADIMIR AT THE FOOT OF A MOUNTAIN
VLADIMIR IN A TIME MACHINE
VLADIMIR IN A STEEL MILL
VLADIMIR EAVESDROPPING ON CHEKHOV AND ARISTOTLE
VLADIMIR LEANING ON A TELEPHONE POLE
VLADIMIR AS A MATRYOSHKA NESTING DOLL
VLADIMIR WITH A GUN IN HIS MOUTH
VLADIMIR HAUNTING YOUR MOTHER

IF YOU'RE LUCKY
Six hours later Vladimir might say hello. [*Vladimir's voice is thin and breathless as though he has just run up a steep flight of stairs.*] The light on Vladimir is thick and elegiac. You are, indeed, in the company of the dead and chatting with the dead.

[*Enter Vladimir in a trench coat. He fishes in his pockets for something, removing assorted articles: a beer bottle, a wristwatch, ticket stubs, at least half a dozen keys, a drumstick, eyeglasses, a tube of toothpaste. When his pockets are empty, he removes the coat and scratches his head, pondering in the nude.*]

Vladimir may appear to have been drinking. The glow of his jaws may suggest he has a burning lightbulb in his mouth. A little red ribbon of blood may run down his forehead like a little red ribbon.

Some Vladimirs may come with props and predisposed poses. Nabokov, for example, may open his mouth to reveal a beautiful trembling butterfly. Tretchikoff may come wearing a kimono and makeup. Chertkov might insist you call him Leo Tolstoy, his spiritual twin. Refusing to speak plainly, Lenin will likely sing his news and conjectures. "Capitalism lives on the witless blood of the young," he will likely sing in a gruff, operatic falsetto.

POSSIBLE QUESTIONS FOR VLADIMIR
What do I love, and why should I love?
Who do I know named Vladimir, and who will care to hear about Vladimir?
Will touch be necessary in the future?
If the chief faith of my people is the chief business of my people, what is the chief flaw of my people?
If the chief obsession of my people is the chief business of my people, what will be the chief downfall of my people?
What is the meaning of meaning?

(The answers of the Vladimirs may be varied, imaginative, and occasionally indecipherable.)

POSSESSION
If the séance is going well, invite the ghost into your body. It will be akin to being a two-headed, one-manned proletariat. You will be tired people. It will be like being asleep and hating to sleep. Like trying to hear oneself snore loudly. When a little more time has passed, you will experience a wonderful futuristic mood. You will be born in a state longing for life.

WHAT NOT TO DO

Avoid Summoning Multiple Ghost Vladimirs, they will agree on nothing:

Vladimir #1: I remember like it was now.
Vladimir #2: No, it's me who remembers like it was now!
Vladimir #3: You remember like it was now, but I remember like it was before.
Vladimir #4: But I remember before like it was now.
Vladimir #5: I remember how it was even before that, now!
Vladimir #6: There is no before now. I remember now!

AVOID SUMMONING TOO MANY LIVING VLADIMIRS

I'll tell you what happened to me. Morning after the last séance, I woke to the chatter of four or five dozen living Vladimirs. Suits in the varied colors of smoke and leaves at the tail end of autumn, long hair, no hair, black, white, gray men, a few curious adolescent boys and even a plump potato-skinned babushka and her granddaughter namesake: the Vladimiras, named after the grandmother's father who was there as well encased in the small tinfoil frame the old woman carried. Yes, I told her, you may sit for a portrait, and later I drew her holding her father's picture to her chest like a certificate of birth. I began with a vine charcoal and thought for a moment it should remain in that medium: a series of smudged lines symbolizing Babushka-Vladimira's mortality—a contradiction in image given her girth, her husky gypsy voice. One of the veteran Vladimirs waiting outside my studio heard her chuckle and swore I was in the company of a chain-smoking soldier newly returned from war. He stepped into the room looking for the source of the laughter. Embarrassed, he later told me how many friends he'd lost to war. I painted him in green and blue brushstrokes, focusing primarily on how intently he focused on the floor. I finished two or three portraits an hour for eight or nine hours straight that day. To give everyone the same eye color, I mixed a shade akin to water when a fish flashes beneath it. You

know how in love I am with the dead, but my goodness, when Vladimira, the granddaughter of Vladimira the babushka, settled before my easel, she emitted a strange heat that cannot be captured in paint. The portraits have all been destroyed. And truly, I prefer the company of ghosts—they take up much less space.

HOW TO END THE PARTY
If, for any reason, things start to get out of control, quickly beg the spirit to go in peace, then break the circle of hands, extinguish the candles, and turn on the lights. As the sun rises, there is a chance you'll find a Vladimir huddled in the tub upstairs. His hands and feet may hang over the sides. Tragic people are theatrical. Theatrical people are tragic. You or one of your guests should declare, "I'm all even with life!" and you all should then abruptly head outdoors.

AFTER THE SÉANCE
Vladimir means "to rule the world." Vladimir means to give meaning to the world. Consequently, venerable, vehement Vladimirs may continue to appear. Violent, vagabond, vandal Vladimirs. Or virtuoso Vladimirs. Virtuous Vladimirs. Kidnapped, mummified, gift wrapped, bitch-slapped, riffraff Vladimirs. I do not know what will happen. Vladimir may appear in a clean-shaven, psychotic visage. Bald as a cloud of trousers. Dead, he may wish to be dead again.

COLLAPSED LYRICS OF A SÉANCE

FEEBLE HEART BEWARE / THE DEAD ARE LONELY / A FAINT WITCH-CRAFT AGAINST DEATH / SELF DESTRUCTION PERFORMED BY STARS / I AM TOO TOUGH TO DIE / WE ARE LONELY / OUR SYMPTOMS IN-CLUDE METAPHYSICAL HUNGER / THE MOUTH ON YOUR NAVEL IS YOUR OWN / A TWO-DIMENSIONAL WEEPING / A SERIES OF UNAC-KNOWLEDGED SACRIFICES / A MIRROR IN THE TOWERING DUSK GROANING AND BRUSHING / ONE MUST CONJURE CHANGE / I HAVE CHANGED / FACE A PROVINCIAL ROOM / A WINTER / LET'S SAY YOU'VE GONE BACK IN TIME / PLAGUE PNEUMONIA PARANOIA IN-TELLECTUAL STARVATION SPIRITUAL EXHAUSTION PRATFALLS MIS-STEPS / IT SHOULD BE TWELVE OCLOCK / FIVE SOLDIERS SHOULD PASS THE SPEED OF LIGHT / NEGATIVE AND POSITIVE TRANSGRES-SIONS / A MEANS OF DISAPPEARANCE / CANDLES THAT DOUBLE EX-POSURE / THERE IS SUCH A THING AS TOO MUCH SYMBOLISM / DIS-TRACTION COOING IN A DARK PANELED ROOM / AN UNCOUPLED BREAST WITHOUT WINDOWS / AND THE MECHANICAL SOUL / A CERTAIN NOBILITY IS IMPLICIT / I HAVE TWO HANDS AND THEY ARE NOT AS SIMILAR AS THEY SEEM / THE GLOW SUGGESTS A BURNING A BEAUTIFUL TREMBLING BLOOD / WHAT DO I LOVE AND WHY SHOULD I / WHO DO I KNOW AND WHO WILL CARE TO BE UNNEC-ESSARY / INVITE THE GHOST INTO YOUR BODY / TIRED PEOPLE / A WONDERFUL FUTURISTIC MOOD / BE BORN LIKE IT WAS NOW / BE-FORE LIKE IT WAS NOW / EVEN BEFORE THAT / I REMEMBER NOW LIKE IT WAS NOW / THE CHATTER OF SMOKE AND LEAVES / AND NAMESAKE AND MORTALITY AND BRUSHSTROKES / BENEATH A NAME / THE NAME AS THE SUN RISES / EVEN WITH LIFE / MEANING WORLD / I DO NOT KNOW WHAT WILL HAPPEN / A CLOUD MAY WISH TO BE DEAD AGAIN

III.

A CIRCLING MIND

THE ROSE HAS TEETH

after Matmos and M. Zapruder

I was trying to play the twelve-bar blues
with two bars. I was trying to fill the room
with a shocked and awkward color, I was trying
to limber your shuffle, the muscle wired
to muscle. I wanted to be a lucid hammer.
I was trying to play like the first mechanic
asked to repair the first automobile.
Once, Piano, every man-made song could fit
in your mouth. But I was trying to play Burial's
"Ghost Hardware." I was trying to play Matmos's
"Roses and Teeth for Ludwig Wittgenstein."
I was trying to play the sound of applause
by trying to play the sound of rain.
I was trying to mimic the stain on a bed,
the sound of a woman's soft, contracting bellow,
the answer to who I am. Before I trust the god
who makes me rot, I trust you, Piano.
Something deathless fills your wood. Because
I wanted to be invisible, I was trying to play
like a woman blacker than an unpaid light bill,
like a white boy lost in the snow. I wanted to be
a ghost because the skull is just a few holes
covered in meat. The skin has no teeth.
I was trying to play what I felt singing
in the mirror as a boy. I was trying to play
what I overheard: the old questions, the hunger,
the rattle of spines. The body that only loves
what it can touch always turns to dust.
What would a mother feel if her child sang

"Sometimes I Feel Like a Motherless Child"
too beautifully? A hole has no teeth.
A bird has no teeth. But you got teeth, Piano.
You make me high. You make me dance
as only a sail can dance its ragged assailable dance.
You make me believe there is good in me.
My lady, she dreams I am better than I am.
I was trying to play "Mouhamadou Bamba"
like a band of Africans named after a tree.
A tree has no teeth. A horn has no teeth.
Don't chew, Piano. Don't chew, sing to me,
you fine-ass lounging harp. You fancy engine
doing other people's work. I was trying to play
the sound of an empty house because
that's how I get by when the darkness in my body
starts to bleed. I was trying to play "Autumn Leaves"
because that's what my lady's falling dress
sounds like to me. Before you, Piano, I was just a rap
of knuckles on a windowsill. I am filled with the sound
of my lover's breathing and only you can bring it out of me.

To make the servant in the corner unobjectionable
Furniture, we must first make her a bundle of tree parts
Axed and worked to confidence. Oak-jawed, birch-backed,

Cedar-skinned, a pillowy bosom for the boss infants,
A fine patterned cushion the boss can fall upon.
Furniture does not pine for a future wherein the boss

Plantation house will be ransacked by cavalries or calvary.
A kitchen table can, in the throes of a yellow fever outbreak,
Become a cooling board holding the boss wife's body.

It can on ordinary days also be an ironing board holding
Boss garments in need of ironing. Tonight it is simply a
Place for a white cup of coffee, a tin of white cream. Boss calls

For sugar and the furniture bears it sweetly. Let us fill the mouth
Of the boss with something stored in the pantry of a house
War, decency, nor bedeviled storms can wipe from the past.

Furniture's presence should be little more than a warm feeling
In the den. The dog staring into the fireplace imagines each log
Is a bone that would taste like a spiritual wafer on his tongue.

Let us imagine the servant ordered down on all fours
In the manner of an ottoman whereupon the boss volume
Of John James Audubon's *Birds of America* can be placed.

Antebellum residents who possessed the most encyclopedic
Bookcases, luxurious armoires, and beds with ornate cotton
Canopies often threw the most photogenic dinner parties.

Long after they have burned to ash, the hound dog sits there
Mourning the succulent bones he believes the logs used to be.
Imagination is often the boss of memory. Let us imagine

Music is radiating through the fields as if music were reward
For suffering. A few of the birds Audubon drew are now extinct.
The Carolina parakeet, passenger pigeon, and Labrador duck

No longer nuisance the boss property. With so much
Furniture about, there are far fewer woods. Is furniture's fate
As tragic as the fate of an ax, the part of a tree that helps

Bring down more upstanding trees? The best furniture
Can stand so quietly in a room that the room appears empty.
If it remains unbroken, it lives long enough to become antique.

RECONSTRUCTED RECONSTRUCTION

after Rebecca Campbell

Q:

A: The strange thing about the portraits was that sometimes from
within the display case during my rounds as the night guardian
(a part-time job), I could hear them singing to one another.

Q:

A: It was noise if you weren't listening carefully enough, but the kind of
noise you find in the woods behind a farmhouse—the noise of hooves
stomping a cowbell into a bed of dry leaves. Who knew so much genre
could come from sticks and air!

Q:

A: Your guess is good as mine. It may have only been the courthouse
basement (where we kept our town's old photos and whatnots) was
haunted by a tambourine player and fiddler circa Whitman on the
battlefield, a brother and sister name of Quincy and Adelaide.

Q:

A: Looking at them, there was no way of knowing whether they meant
their expressions to be ironic or allegorical. The sister had a faint
mustache and lovely white eyes.

Q:

A: I don't think they were twins, but I'll concede, you can do anything
with makeup and lighting, and I don't even know for sure that their
tune was called "Quixotic Abolitions." Where'd you hear that?

Q:

A: They had no children, but the woman couldn't have had her tubes tied. It was against her godship and moreover it was the Reconstruction era!

Q:

A: I wouldn't say that—I've got manners. He had no chickens and even less knowledge of you and me waiting down the road. His head was asymmetrical, his laughter made a strange pennies-in-a-tin sound when it came from his body, but no, no . . .

Q:

A: There's nothing written about the town's runners-up and third-stringers: Mr. and Mrs. Beauford Wood, who witnessed two, three dozen lynchings between them; Isaiah Davies, the thrice-married banker who supposedly owned one of Abraham Lincoln's handkerchiefs; the boot-wearing widow, Martha Herman; Mr. and Mrs. Knot, who, being some manner of immigrant with no concept of the silent *K*, announced themselves as "Kinnot"—but that's why I'm giving them a shout-out here. You should look into *their* stories.

Q:

A: He ain't in the photos I've seen, but yes, there was a field hand with enough muscle to muscle the land. I'm willing to bet he was blacker than you and me. Once or twice the postman saw him down on his hands and knees in the field, not like someone praying or weeping but someone waiting to be transformed back into a beast. Word was, he snapped and tied the couple up in the barn. (Could be fieldwork inspired in him an inkling of revolutionary violence.)

Q:

A: No, I wouldn't say that. You seem to wrongly think that I think of him as the wrongdoer in this moral calculus.

Q:

A: That's my point.

Q:

A: Who knows, who knows. The future came dragging a blue carpetbag up the long, dusty road. In time the night would be pregnant with stars and I would be back to working the earth. Anyway, you can see how what happened to them could be made easily into a song . . .

And here is all we'll need: a card deck, quartets of sun people
Of the sort found in black college dormitories, some vintage
Music, indiscriminate spirits, fried chicken, some paper,

A writing utensil, and a bottomless Saturday. We should explore
The origins of a derogatory word like *spade* as well as the word
For feeling alone in polite company. And also the implications
Of calling someone who is not your brother or sister,

Brother or Sister. So little is known of our past, we can imagine
Damn near anything. When I say maybe slaves held Spades
Tournaments on the anti-cruise ships bound for the Colonies,
You say when our ancestors were cooped on those ships

They were not yet slaves. Our groundbreaking film should begin
With a low-lit den in the Deep South and the deep-fried voice
Of somebody's grandmother holding smoke in her mouth
As she says, "The two of Diamonds trumps the two of Spades

In my house." And at some point someone should tell the story
Where Jesus and the devil are Spades partners traveling
The juke joints of the 1930s. We could interview my uncle Junior
And definitely your skinny cousin Mary and any black man

Sitting at a card table wearing shades. Who do you suppose
Would win if Booker T and MLK were matched against Du Bois
And Malcolm X in a game of Spades? You say don't talk
Across the table. Pay attention to the suits being played.

The object of the game is to communicate invisibly
With your teammate. I should concentrate. Do you suppose
We are here because we are lonely in some acute diasporafied
Way? This should be explored in our film about Spades.

Because it is one of the ways I am still learning what it is
To be black, tonight I am ready to master Spades. Four players
Bid a number of books. Each team adds the bids
Of the two partners, and the total is the number of books

That team must try to win. Is that not right? This is a game
That tests the boundary between mathematics and magic,
If you ask me. A bid must be intuitive like the itchiness
Of your upper lip before you sip strange whiskey.

My mother did not drink, which is how I knew something
Was wrong with her, but she held a dry spot at the table
When couples came to play. It's a scene from my history,
But this probably should not be mentioned in our documentary

About Spades. *Renege* is akin to the word for the shame
You feel watching someone else's humiliation. Slapping
A card down must be as dramatic as hitting the face of a drum
With your palm, not hitting the face of a drum with a drumstick.

You say there may be the sort of outrage induced
By liquor, trash talk, and poor strategy, but it will fade
The way a watermark left on a table by a cold glass fades.
I suspect winning this sort of game makes you feel godly.

I'm good and ready for whoever we're playing
Against tonight. I am trying to imagine our enemy.
I know you are not my enemy. You say there are no enemies
In Spades. Spades is a game our enemies do not play.

And I understand well now, it is beautiful
to be dumb: my tyrannical inclinations, my love
for the prodigal jocks aging from prime time
to pastime, the pixilated, plain people and colored folk

with homemade signs. Cutouts, cutups, ambushes,
bushwhackers. MC Mnemosyne shows up
around midnight like the undetectable dew

weighing down the leaves, and I'm like "Awww, shit!"
Why ain't I dead yet
like the man who wanted to be buried

with the multimillion-dollar Van Gogh he bought?
(Members of the Arts League said no
because there was culture to be made into money.)

The volant statues of the aviary, the jabber-jawed
cable channels, and the book in which nothing is written
but the words everyone uses to identify things
that can't be identified. Not that I ain't spent

the last ten years of my life refining my inner cyborg.
Interview questions included: how did the DJ break his hands,
who's gone to bury the morticians who bury the dead,

and what can one do about the sublime and awful music
of grade school marching bands?
Not that Neanderthals have a sense of the existential.
Me and my forty-leventh cousins lolling, and LOL-ing

like chthonic chronic smoke, like high-water suit pants
and extreme quiet. Everybody clap ya hands.
Like fit girls in fitted outfits, misfits who don't cry enough,

who definitely don't sob but keep showing up sighing.
Everyone loves to identify things that have not been identified.
The rabbit hole, wherever I find it, symbolizes solitude.
So that's exciting. And an argument can be made

on behalf of athletes, rap stars, and various other brothers
who refuse (click here for the entire video)
to wear shirts in public when one considers the beauty

of a black torso. If and when the dashiki is fashionable
again, I will sport it with the aplomb of a peacock plume.
For now, I have a row of coin-size buttons tattooed
down my chest so it looks like I mean business

even when I'm naked. I know that means a lot to you.

MODEL PRISON MODEL

Here in this small, expertly crafted model
You can see the layout of the prison I will erect:
The 17,000 six-by-eight cells, the wards
For dreamers reduced to beggars to my right,

The wards for strangers who might be or become
Enemies to my left. It has taken months
Of sweat and research to design and assemble
This miniature, but with your support

It should only take a year or so to build
To functioning size. Let me direct your attentions
To the barbed-wire fence which thickens
To a virtual cyclone of fangs above the prison.

With a good model to draw upon
I was able to create a terrific somberness
And then lie down and imagine the lives
Of the prisoners and officers inside.

I feel like this is a good time to tell you
My parents and first cousin have worked
Decades as prison guards. Nonetheless,
When I, a black male poet, was asked

To participate in the construction of this vision,
I was surprised. During the uninspired years
I smoked so much I would have set myself aflame
Had I not been weeping half the time.

I am told when my uncle was an inmate,
My father often found him cowering in his cell
Like a folded rag. You will note the imposing
Guard towers at each corner of the prison.

In the yard below I will loose vigilant dogs.
Whether you consider dogs symbols of security
Or symbols of danger depends upon whether
You're inside or outside the fence.

In our current positions around the model
You and I represent the just, the offended
And vengeful, the grief-stricken and not-all-together
Innocent citizens. Take a moment to consider

The prayers and/or insults you might like
To shower upon the new inmates as they arrive.
Even a slur is a form of welcome.
I plan to have the vocalists among the prisoners

Sing for the old men who die there.
Perhaps their songs will soften the picketers.
The prison of the picketer, let me remark,
Is filled with empty riverbeds and the kind

Of desire that only gets tender in fire.
Last night as I finished fashioning hundreds
Of paper clips into the shiny bars between us,
I imagined myself seated before a parole board

Spilling indecipherable jive. Everybody is excited
By freedom. I was reminded of the theory
That says the body is a prison wherein the mind
Resides when I installed the small industrial locks

You see bolting the prison's minuscule doorway.
In fact, if each of you can bend over now and try
Moving to the exit while looking between your legs,
You will have a sense how difficult it is to escape.

SOME MAPS TO INDICATE PITTSBURGH

*after Michael Baldwin and Mel Ramsden, the artists who
make up Art & Language*

THE GREENFIELD MAP TO INDICATE PITTSBURGH ACCORDING TO PENETRATION BY WORK BEYOND THE OBJECT

When I lived there a woman appeared at my stoop ruffled as someone pulled from a nightmare. The rope burns were like burning bracelets on her wrists; the blood in her blush gave her cheeks a sad sunset tint. She was from a mill town, a desolate suburb of basements and cookouts, but I let her in gushing, "Okay, okay, okay," with a sliver of pity. And later when she put her fingers in my mouth, I tasted pepper. Nothing is sure struck with darkness. No one's grief is ever as profound as your own.

THE HILL DISTRICT MAP TO INDICATE PITTSBURGH ACCORDING TO DEVELOPMENT OF AN EVERYDAY CRITIQUE OF FALSE UNIVERSALS

It is perhaps impossible to have a neighborhood without neighbors and a market, but the ghosts believe otherwise. Dust on the theater marquee is undetectable in the twilight. Stand in any district cemetery and there will be a low singing though there will be no singers. The faint stain on the library steps may well be blood, but there will be no corpse. Place your ear to the road and you will hear someone screaming below.

THE NORTHSIDE MAP TO INDICATE PITTSBURGH ACCORDING TO DEVELOPMENT OF THE POLITICS OF REPRESENTATION

Let us look at the North Shore's modernity as would a boy sitting on the bottom of the Monongahela, a muddy word that means "soft, collapsing slopes." Gravity is the only true geography. Rachel Carson, Andy Warhol, Roberto Clemente, no one lives forever here except as bridges under which boys hide from authority and rainfall, the downpour of stadium banter and rebuke. If you fall into the water, you will climb out of the water blacker than you used to be.

THE SOUTHSIDE MAP TO INDICATE PITTSBURGH ACCORDING TO CAPACITIES TO GLIMPSE THE POSSIBILITY OF THE ABSENCE OF PRESENCE, AND THUS THE POSSIBILITY OF CHANGE

After two or three rivers and bus transfers you arrive at a boulevard of dive bars with scarred tabletops. You find patrons with mouths stretching literally ear to ear. They have an absurd number of imperfect teeth and miniature noses. They want to tell you immigrant tales featuring steel, steamships, and orphans. When they invite you to brawl at two a.m. do not refuse. *Brawl* is merely another beautiful word for *dance*.

THE LAWRENCEVILLE MAP TO INDICATE PITTSBURGH ACCORDING TO UNDERSTANDING REALITY AS HYPERREALISTIC

Borders make no sense, but are as familiar and awkward as one body entering another. Imagine a future in which all bridges must be rebuilt and the fundamentals of making an ax from a sharpened stone or making fire have been forgotten—can you make fire or an ax? If you are to live here on out as a bridge, you must never say, "Get off my back." You must say what the water says, "Everybody sing to me, everybody sing with me," and sing.

NEW JERSEY POEM

after Willie Cole's "Malcolm's Chickens I"

One of the many Willies I know wants me to know
there are still bits of hopefulness being made
in certain quarters of New Jersey. It's happening
elsewhere too, obviously, this Willie would say,
but have you seen the pants sagging like the skin
on a famished elephant and the glassy stupor
of counselors in the consultation rooms, the trash
bins of vendettas and prescriptions, have you seen
the riot gear, what beyond hope could be a weapon
against all that? The summer I drove six hours
to Willie Brown's place I found him building
a huge chicken out of brooms, wax, marbles (for eyes),
Styrofoam, and hundreds of matchsticks, but what
I remember is the vague sorrow creasing his face.
Like it wasn't a chicken at all at hand, like he'd never
even seen a chicken in New Jersey, or a feather
or drumstick—which I know to be untrue. A man can be
so overwhelmed it becomes a mode of being,
a flavor indistinguishable from spit. He hadn't done shit
with the letters and poems his wife left behind
when she killed herself. I think she was running,
I think she was being chased. She is almost floating
below ground now. The grave is filled with floodwater,
the roots of trees men planted after destroying the trees
shoot through her hips. Nowadays when I want saltwater
taffy or some of those flimsy plastic hooks good for hanging
almost nothing, I do not go to New Jersey. And I'm sure
no one there misses me with all the afflictions they have
to attend. Grief will boil your eyeballs if you let it.

It is possible to figure too much, to look too much,
to be too verbal, so pigheaded nothing gets done.
In those days, that particular Willie denied he was
ever lonely in New Jersey. His head, he said, was full
of handcrafted tools, and beneath his tongue he claimed
was a button that, when pressed the right way, played
a song, a kind of chain gang doo-wop. To which I said,
Willie, that's bullshit, you stink like a heartbroken man.
I wanted to ask if he'd read the letters his wife left.
Somehow we made it from Atlantic City to the VFW bar
in Trenton without losing ourselves. I drove us through
a pre-storm breeze and a sickish streetlamp twilight
until there was rain on the windshield and voices
dispensing threefold news of what might happen,
what does happen, and why whatever happened did,
the soul's traffic. Somehow we weathered all that.
The chicken is in a museum somewhere now, worth
more than God, I bet, and so much time has passed
I can't be sure which Willie made it. That night we had
some of its smell on our fingers. But the men we found
in the bar's humiliating darkness still invited us in.

SELF-PORTRAIT AS THE MIND OF A CAMERA

after Charles "Teenie" Harris

Because everyone and everything we see is a self-portrait,
We get to be the hangouts and the hot spots on the blouse
Of a woman whose legs slant toward eternity. We get to be

The woman as her shoes make a song on the pavement
As well as the whole day bending down to listen, the skyline,
The front yard and riverfront windows, the gloved or manicured

Hands, every manner of cure for what ails the interior. We get to be
The vessels of duration and feasible profit, and the men building
A roost of coins and prospects out of ingots, ignitions, slabs

And sheets of metal reflecting vibrant broken colors. We get to be
All that, Brothers and Sisters, when we lie back and let the agent
Of beauty lay hands on us. What if, in your previous life,

You were born a black man's camera? Suppose you lived
As something filled with a light and darkness that's defined
By what it touches. What if you could hold everything

You behold in a chamber inside yourself: a sense of the existential,
A sense that color sometimes conspires against you, a sense
There are people who would be anonymous without you?

<p style="text-align:center">*</p>

You are an instrument of visible music, Camera, a focused mind
In love with witness. We look at you looking at us grinning ear to ear
Some afternoon as the light hangs on us like jewelry. We can be

The woman waiting to have your lens cover her body like praise
Poured to preserve the loveliness others have tried to erase
As well as the young men who sigh *Amen, Good God, Goddamn*

Beholding her. We live so lively in you, Camera. Even the furniture
Misses us when we're gone. When only the satin and stains
And dark shot glasses remain, Camera, you help us feel

A little less empty. You make me feel a bit less blue, Camera,
You do. We slide into your suit and move on down the avenue.
Because everyone and everything is a self-portrait, we get to be

The upturned salutes, the bouquets at rest, the expressions
That evaporate sadness, the punctuating rain, the clouded
Judgments and clouded air suffocating the city, we get to be

The flame in a black man's hands, thanks to you. Drawn
To illumination and to the darkest basements too, we slide
Across the floorboards with our legs kicked up, we slide

Across the troubled waters like dancers in a blues ballet,
Slide into tomorrow where no one expires
Because there is no time to lose. The scars we cover

In ornaments and rouge you uncover, the youth we lose
You make permanent. Camera, you really have to love us
To keep us from disappearing. Bodies of solar-powered soul,

Most of what we know of the past we know because of you.
We get to be any brother in gold worn to blind a gaze with no heart
In it. Mistranslations, obfuscations, combustible insults,

Sideways assaults. Hold us, Camera, until we are not as black
As what they called us before they called us what they call us now:
We are blacker. We get to be as elusive as a woman

Sliding through the smoke of a man's embrace. We get to be
Corner boys with bongos, a junction of tongues, an image
Of verbal bang-abouting, sparks of wet "say-what"

In the glad mouth. The world gets made, people get together
In its architecture, fringe and sequins slip from the edges
Of a hot body the angles the onlookers calculate.

We are on the side of *Good God* as well as the side of *Goddamn*.
To be a black man's camera is to live covered in a sweat
That becomes all the water you need as long as you have to live.

*

The women will be here still when they are too old
To recognize themselves decked in matching hats
And a carriage that could make a suitor run out for flowers.

To hold time still, it may well be that God gave us photographs
And photographers. It's not the same as painting or motion
Pictures: holding something you can press your lips to.

When an image is sucked into the camera, it almost sounds
Like sugar: *sshhhka, sshhhka*. It almost sounds like change
Falling into change, coins clinking in a restless pocket.

When the image is consumed, it almost sounds like the wetness
Of two bodies clicking into one another, like a soft pucker,
A clucking issues as the eye swallows the picture.

I need metaphor to describe it. I cannot hear the black man
Say, "Look into the camera." I cannot hear the whispers
Or ruckus recorded or deconstructed in the scene,

But I know there are three kinds of looking in every picture:
The way the photographer looks, the way the subject looks,
And, Brothers and Sisters, the way it all looks to you.

*

Camera, I cannot say how I came to love you despite the way
You show me the things I will give up and the things to be
Taken from me. You make us people with no words

For *destructible* or *death*, you make us our mothers and fathers,
Our durable blood, our *Kiss-My-Ass* or *Kiss-Me-Baby*,
Our never-ending ends, the lovely girls who smile in a way

That makes anyone looking at them feel lovely. I will shuck
My socks and shoes for you, Camera, I'll show my toes,
I'll shuck my clothes and pose, I'll shuck my skin until my rhythm

Is exposed. Motion blur. Shutter speed. A standing dance
With someone's "again" strung out overhead, the sisters
With thunder in their grooves, the rise and footfall

Of what's chased off, the skipped stone of what's tossed out,
The song of a dress and dolled-up hairdo, of styled and stylish
Measure, of styles of beauty and styles of being and possibility.

*

I believe an archive of moments can become momentous.
I believe everyone is everyone and everything is everything,
But People, it's okay if it all looks different to you.

Not even two eyes in the same head see the same things.
I try to never confuse plain facts with plain truths.
But if you were a camera, your parts would be held

Together by industry and idealism, the photographer's eye
Dealing imagery the idle and idyllic and idols held lightly
In a square of two-dimensional exactitudes, a refuge

For ruined buildings and faces no one could envision.
You'd be something that gives the past an appearance,
A viewfinder, a timer passed down through history,

Down from the pinholes of Euclid and Aristotle's eclipse,
From Daguerre's daguerreotype and John Herschel's blueprint.
If you were a camera, you'd get to be covered in fingerprints,

An ion sheen, an emulsion of silver crystals, and the imagery
Man calls memory would live in you. You'd be as stitched together
As the people who migrated to northern cities, a chimeric patchwork

Of high and low places, of scavenging and fire, miracles and myths
That say you probably should not exist. Negative and positive
Scenes would wait to be processed in you. Brothers and Sisters,

You'd get to be rearranged and live as if someone was blessing you.
Head shot, aperture, perspective, assembled resemblances,
The magic of a kind of photosynthesis: you'd get to be a mind

Light and darkness pass through, a form formed from a form
Light and darkness pass through. You'd get to hold everything
You beheld, and good God, everything would take hold of you.

I can imitate the spheres of the model's body, her head,
Her mouth, the chin she rests at the bend of her elbow,
But nothing tells me how to make the pupils spiral

From her gaze. Everything the eye sees enters a circle,
The world is connected to a circle: breath spools from the nostrils
And any love to be open becomes an O. The shape inside the circle

Is a circle, the egg fallen outside the nest the serpent circles
Rests in the serpent's gaze the way my gaze rests on the model.
In a blind contour drawing the eye tracks the subject

Without observing what the hand is doing. Everything is connected
By a line curling and canceling itself like the shape of a snake
Swallowing its own decadent tail or a mind that means to destroy itself,

A man circling a railway underpass before attacking a policeman.
To draw the model's nipples I have to let myself be carried away.
I love all the parts of the body. There are as many curves

As there are jewels of matrimony, as many whirls as there are teeth
In the mouth of the future: the mute pearls a bride wears to her wedding,
The sleeping ovaries like the heads of riders bunched in a tunnel.

The doors of the subway car imitate an O opening and closing,
In the blood the O spirals its helix of defects, genetic shadows,
But there are no instructions for identifying loved ones who go crazy.

When one morning a black man stabs a black transit cop in the face
And the cop, bleeding from his eye, kills the assailant, no one traveling
To the subway sees it quickly enough to make a camera phone
witness.

The scene must be carried on the tongue, it must be carried
On the news into the future where it will distract the eyes working
Lines into paper. This is what blind contour drawing conjures in me.

At the center of God looms an O, the devil believes justice is shaped
Like a zero, a militant helmet or war drum, a fist or gun barrel,
A barrel of ruined eggs or skulls. To lift anything from a field

The lifter bends like a broken O. The weight of the body
Lowered into a hole can make anyone say *Oh*: the onlookers,
The mother, the brothers and sisters. Omen begins with an O.

When I looked into my past I saw the boy I had not seen in years
Do a standing backflip so daring onlookers called him crazy.
I did not see a moon as white as an onion but I saw a paper plate

Upon which the boy held a plastic knife and sopping meat.
An assailant is a man with history. His mother struggles
To cut an onion preparing a meal to be served after the funeral.

The onion is the best symbol of the O. Sliced, a volatile gas stings
The slicer's eyes like a punishment clouding them until they see
What someone trapped beneath a lid of water sees:

A soft-edged world, a blur of blooms holding a coffin afloat.
The onion is pungent, its scent infects the air with sadness,
All the pallbearers smell it. The mourners watch each other,

They watch the pastor's ambivalence, they wait for the doors to open,
They wait for the appearance of the wounded one-eyed victim
And his advocates, strangers who do not consider the assailant's funeral

Appeasement. Before that day the officer had never fired his gun
In the line of duty. He was chatting with a cabdriver
Beneath the tracks when my cousin circled him holding a knife.

The wound caused no brain damage though his eyeball was severed.
I am not sure how a man with no eye weeps. In *The Odyssey*
Pink water descends the Cyclops's cratered face after Odysseus

Drives a burning log into it. Anyone could do it. Anyone could
Begin the day with his eyes and end it blind or deceased,
Anyone could lose his mind or his vision. When I go crazy

I am afraid I will walk the streets naked, I am afraid I will shout
Every fucked-up thing that troubles or enchants me, I will try to murder
Or make love to everybody before the police handcuff or murder me.

Though the bullet exits a perfect hole it does not leave perfect holes
In the body. A wound is a cell and portal. Without it the blood runs
With no outlet. It is possible to draw handcuffs using loops

Shaped like the symbol for infinity, from the Latin *infinitas,*
Meaning *unboundedness.* The way you get to anything
Is context. In a blind contour it is not possible to give your subject

A disconnected gaze. Separated from the hand the artist's eye
Begins its own journey. It could have been the same for the Cyclops,
A giant whose gouged eye socket was so large a whole onion

Could fit into it. Separated from the body the eye begins
Its own journey. The world comes full circle: the hours, the harvests,
When the part of the body that holds the soul is finally decomposed

It becomes a circle, a hole that holds everything: blemish, cell,
Womb, parts of the body no one can see. I watched the model
Pull a button loose on her jeans and step out of them

As one might out of a hole in a blue valley, a sea. I found myself
In the dark, I found myself entering her body like a delicate shell
Or soft pill, like this curved thumb of mine against her lips.

You must look without looking to make the perfect circle.
The line, the mind must be a blind continuous liquid
Until the drawing is complete.

ARS POETICA FOR THE ONES LIKE US

after Mark Rothko & Leonard Cohen

I like the story about the man who talks
God into letting him live until he is done
With his masterwork. In some versions

He is a painter, but in this one he is a singer
Who then sings every sentence, whose song
Becomes a poem that does not end

Because it is eternally revised. Who can say
Whether Orpheus, when he found honey
In other hives, did not sing to let the devil know

His body was alive? He was the first to grieve,
Years in advance, the news of his death.
At the wake I explained that the poem could be

Thought of as a house: a bedroom where a boy
Undresses before a slightly older girl and vanishes
In her shade; a basement where the furnace

And subliminal pipes are kept; an attic
Where aesthetic and spiritual innuendos drift.
If I could have stepped out of the poem,

My feet would have remained four or five inches
Above ground because the ground was covered
In four or five inches of snow. It is breath

That makes the tragic endurable. It is earth
That provides our basis for being rooted
To ourselves. It is evening that lets us,

For an instant, be possessed by someone else.
I believed, for example, that I was in control.
The girl, I have almost forgotten her name,

Told me the poem would want the windows
Closed. I tried drawing her face to my face
So that her face could be exposed.

From inside the poem I was asked to map
The world outside and the adventure to unfold.
I looked at the window, but I could not see

Through the window because it resembled
A painting of light coloring a veil
Shaped like a window. Some things in this world

Do not depend on speech to be felt.
Remember too that the eyes are not flesh,
That crisis is initiated by the absence of witness,

That Orpheus, in time, became nothing
But a lying-ass song
Sung for the woman he failed.

Notes, references, and inspirations for the poems can be found online at http://terrancehayes.com/notes-drawn/.

VICTORIA SMITH

Terrance Hayes is the author of *Lighthead* (Penguin, 2010), winner of the 2010 National Book Award, and finalist for the National Book Critics Circle Award. His other books are *Wind in a Box* (Penguin, 2006), *Hip Logic* (Penguin, 2002), and *Muscular Music* (Tia Chucha Press, 1999). His honors include a Whiting Writers' Award, a National Endowment for the Arts Fellowship, a United States Artists Fellowship, a Guggenheim Fellowship, and a MacArthur Fellowship.

JOHN ASHBERY
Selected Poems
Self-Portrait in a Convex Mirror

TED BERRIGAN
The Sonnets

LAUREN BERRY
The Lifting Dress

JOE BONOMO
Installations

PHILIP BOOTH
Lifelines: Selected Poems,
* 1950–1999*
Selves

JULIANNE BUCHSBAUM
The Apothecary's Heir

JIM CARROLL
Fear of Dreaming:
* The Selected Poems*
Living at the Movies
Void of Course

ALISON HAWTHORNE DEMING
Genius Loci
Rope

CARL DENNIS
Another Reason
Callings
New and Selected Poems
* 1974–2004*
Practical Gods
Ranking the Wishes
Unknown Friends

DIANE DI PRIMA
Loba

STUART DISCHELL
Backwards Days
Dig Safe

STEPHEN DOBYNS
Velocities: New and Selected
* Poems, 1966–1992*

EDWARD DORN
Way More West: New and
* Selected Poems*

ROGER FANNING
The Middle Ages

ADAM FOULDS
The Broken Word

CARRIE FOUNTAIN
Burn Lake
Instant Winner

AMY GERSTLER
Crown of Weeds: Poems
Dearest Creature
Ghost Girl
Medicine
Nerve Storm

EUGENE GLORIA
Drivers at the Short-Time Motel
Hoodlum Birds
My Favorite Warlord

DEBORA GREGER
By Herself
Desert Fathers, Uranium
* Daughters*
God
Men, Women, and Ghosts
Western Art

TERRANCE HAYES
Hip Logic
How to be Drawn
Lighthead
Wind in a Box

NATHAN HOKS
The Narrow Circle

ROBERT HUNTER
Sentinel and Other Poems

MARY KARR
Viper Rum

WILLIAM KECKLER
Sanskrit of the Body

JACK KEROUAC
Book of Sketches
Book of Blues
Book of Haikus

JOANNA KLINK
Circadian
Excerpts from a Secret Prophecy
Raptus

JOANNE KYGER
As Ever: Selected Poems

ANN LAUTERBACH
Hum
If in Time: Selected Poems,
* 1975–2000*
On a Stair
Or to Begin Again
Under the Sign

CORINNE LEE
PYX

PHILLIS LEVIN
May Day
Mercury

PATRICIA LOCKWOOD
Motherland Fatherland
* Homelandsexuals*

WILLIAM LOGAN
Macbeth in Venice
Madame X
Strange Flesh
The Whispering Gallery

ADRIAN MATEJKA
The Big Smoke
Mixology

MICHAEL MCCLURE
Huge Dreams: San Francisco
* and Beat Poems*

ROSE MCLARNEY
Its Day Being Gone

DAVID MELTZER
David's Copy: The Selected
* Poems of David Meltzer*

ROBERT MORGAN
Terroir

CAROL MUSKE-DUKES
An Octave Above Thunder
Red Trousseau
Twin Cities

ALICE NOTLEY
Culture of One
The Descent of Alette
Disobedience
In the Pines
Mysteries of Small Houses

WILLIE PERDOMO
The Essential Hits of
* Shorty Bon Bon*

LAWRENCE RAAB
The History of Forgetting
Visible Signs: New and Selected
* Poems*

BARBARA RAS
The Last Skin
One Hidden Stuff

MICHAEL ROBBINS
Alien vs. Predator
The Second Sex

PATTIANN ROGERS
Generations
Holy Heathen Rhapsody
Wayfare

WILLIAM STOBB
Absentia
Nervous Systems

TRYFON TOLIDES
An Almost Pure Empty Walking

ANNE WALDMAN
Gossamurmur
Kill or Cure
Manatee/Humanity
Structure of the World
* Compared to a Bubble*

JAMES WELCH
Riding the Earthboy 40

PHILIP WHALEN
Overtime: Selected Poems

ROBERT WRIGLEY
Anatomy of Melancholy and
* Other Poems*
Beautiful Country
Earthly Meditations: New and
* Selected Poems*
Lives of the Animals
Reign of Snakes

MARK YAKICH
The Importance of Peeling
* Potatoes in Ukraine*
Unrelated Individuals Forming
* a Group Waiting to Cross*